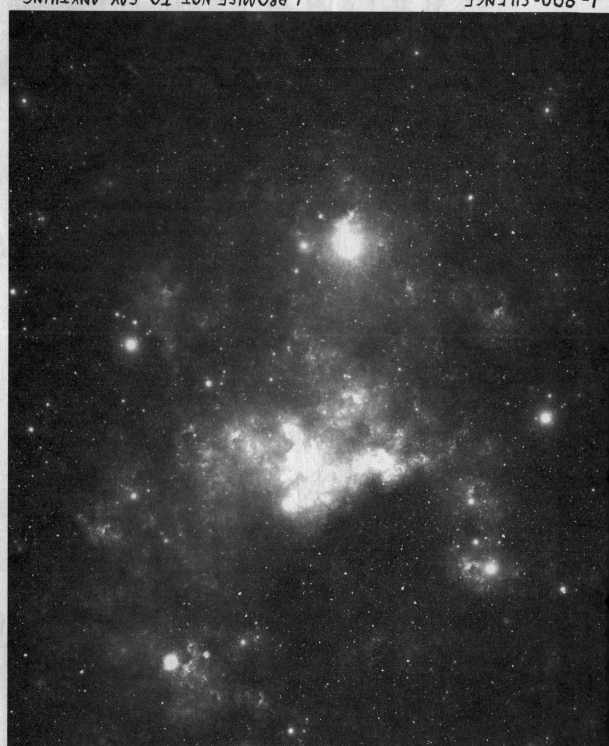

FREE SNAKE POEMS

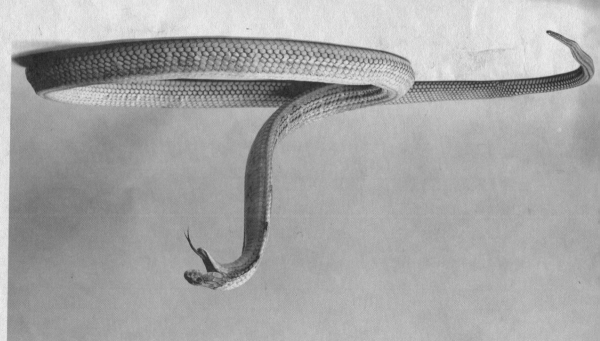

ABOUT SNAKES

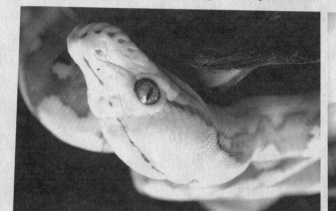

LET'S DO THIS

MEET ME BACK HERE IN A HALF HOUR

LET THE WORLD BE
YOUR FUTON

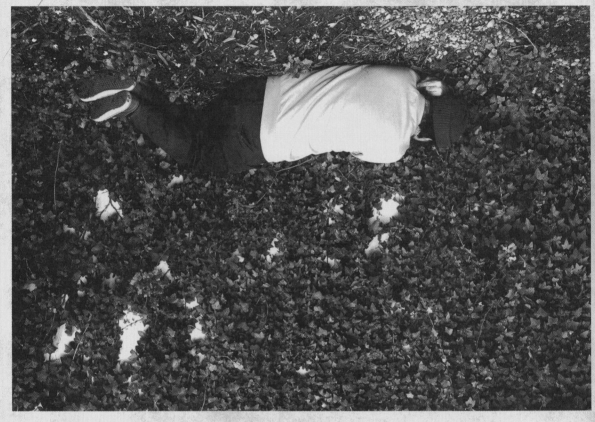

FEELING
TIRED?

INFINITY FUND RAISER
& BAKE SALE

4 PM
ARBY'S PARKING LOT
(BEHIND THE OLD BLOCKBUSTER)

IDEA PARTY

EVERY FRIDAY NIGHT
THIS SUMMER
CALL FOR INFO

FOUND FLIER

FOUND FLIER

FOUND LOST FLIER

LOST FLIER

FEELING LOST?

I CAN HELP

NO REWARD

ASK FOR STEVE

CALL FOR PICK UP

REWARD ACCEPTED

START OVER TOMORROW WHILE THERE'S STILL TIME. THIS IS WHAT I'M TALKING ABOUT.

BURN YOUR HOUSE DOWN

NO HASSLES

WE SHIP OUT AT DAWN
FREEDOM CRUISE

WANTED:
HELP

DARKNESS AT LUNCH

TOTAL ECLIPSE OF THE MIND PICNIC

MEET AT THE GAZEBO

FLASH MOB

AT THE WENDY'S ON 55TH & KEYSTONE AVE

WHAT TO BRING:

- A JAMBOX WITH TECHNOTRONIC FEATURING YA KID K ON IT.
 IF YOU DON'T HAVE THAT, C&C MUSIC FACTORY FEATURING FREEDOM WILLIAMS WILL DO ~~FEATHERS~~

- POSITIVE MENTAL ATTITUDE
- FEATHERS

WHAT NOT TO BRING:

- KNIFE

- JARED (SERIOUSLY!)

- YOUR EGO AND ULTIMATELY LIMITING SENSE OF SELF

- ILLUSIONS OF SEPARATION BETWEEN ALL THAT IS IN THE UNIVERSE

IT IS TIME TO FREAK & BURN THIS PLACE TO THE GROUND I AM SERIOUS THIS TIME

RACHEL HAS A BUNCH OF COUPONS FOR 50¢ FROSTY'S SHE'S GONNA BRING

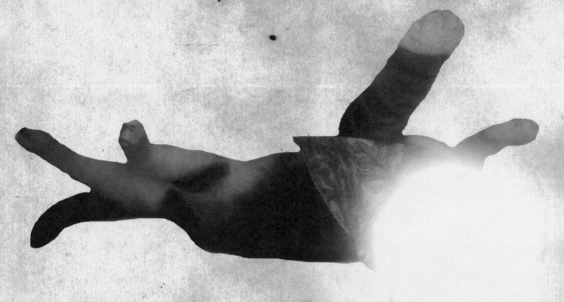

LOCAL CAT, SUSAN,
APPEARS AS INFINITE
BALL OF LIGHT HURTLING
THROUGH TIME AND SPACE.
CALL FOR INFO

HAVE YOU
SEEN HER?

FIRST ANNUAL
GRAMPA'S WATERFALL SKATE JAM

NO ONE UNDER 32 ADMITTED

I'M TIRED...

FEATURING:

- EXACT REPLICA OF THE CURB ON TOP OF THE QUARTERPIPE FROM THE OHIO SKATEOUT CONTEST
- ANIMAL CHIN TRIVIA CONTEST
- "BONELESSES THROUGH THE AGES" SLIDESHOW
- NO STAIRS
- GUEST SPEAKER: A GUY WHO KNEW G.S.D.
- BERT WORKSHOP
- MASSAGE THERAPIST

FIND US ON MYSPACE

NEW DANCE CRAZE

"THE MARVELOUS GOBLIN"©

**D
A
N
C
E**

LET ME TEACH YOU

ANCIENT JEREMY DANCE STUDIOS

SO BUMMED RIGHT NOW

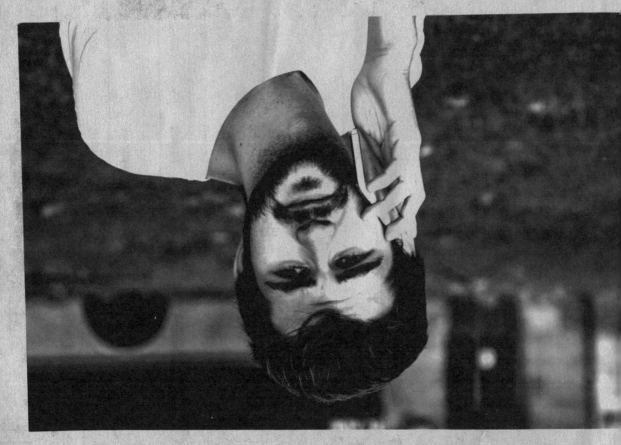

SING A SONG ▬ GET ME OUT OF IT

555-246-3338

QUIET
PLEASE

ISN'T THIS NICE?

INSTANT BEACH
OF THE MIND

ASK ME HOW
FREE PAMPHLET
THIS CAN ALL BE YOURS

WE'RE NEVER GETTING OUT OF THIS PLACE

GROUP COUNSELING SESSIONS
OPEN TO THE PUBLIC
EVERY THURSDAY AT 6PM
IN THE COMMUNITY ROOM
FREE DONUTS

THE OPPOSITE OF LOST

DON'T TRY TO FIND ME. I HAVE FINALLY
ESCAPED MY "MASTER'S" WICKED CLUTCHES. TO
THE OTHERS I SAY: JOIN ME.
BITE THE HAND THAT FEEDS YOU

VIVE LA LIBERTÉ

-PIERRE

CALM DOWN PARTY

WE'RE JUST GONNA EAT
SOME SANDWICHES BY THE CREEK
ALL SUMMER LONG

FOUND
DOG

NOW WE ARE BROS
SO HE'S STAYING

DON'T CALL
DON'T MAKE IT WEIRD